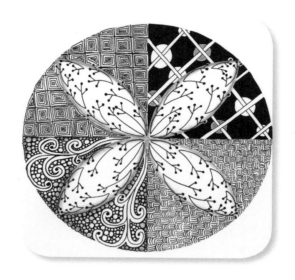

The Zentangle® Untangled Workbook
A Tangle-a-Day to Draw Your Stress Away

Kass Hall

NORTH LIGHT BOOKS
Cincinnati, Ohio
CreateMixedMedia.com

Contents

For bonus content including more practice tiles, more Zendala starters and creative inspiration, scan the QR code with your smartphone's QR code reader. Or visit CreateMixedMedia.com/zentangle-untangled-workbook.

What You Need

Fabriano Zentangle® tiles

Graphite pencil

Notebook

Prismacolor Blender Pencil

Sakura Pigma Micron pens

Zentangle® Kit

JUN 16 2014

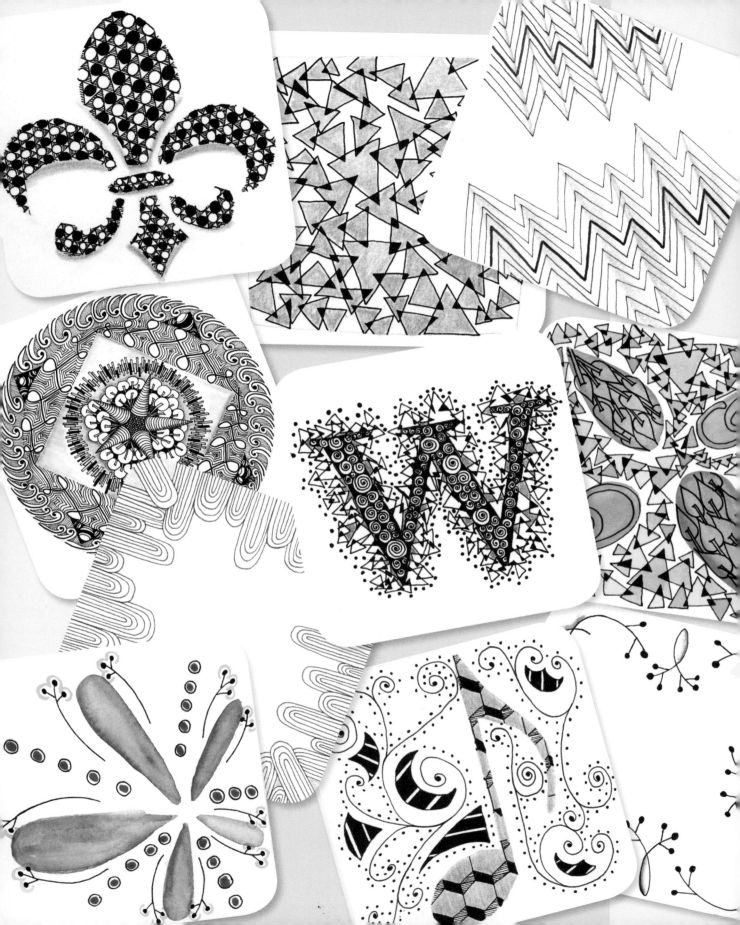

Introduction

Welcome to *The Zentangle® Untangled Workbook*! I'm glad you're here.

The Zentangle® Untangled Workbook is a complement to my first book, *Zentangle® Untangled*. In that, I wrote about my Zentangle® experience, explained how to get started and demonstrated many ways you could use Zentangle in other artistic pursuits.

This workbook is a little different from the last book. Here we work with the three tangle patterns I introduced in *Zentangle® Untangled* (*Honeycomb*, *Starfish* and *Five-Oh*), as well as four brand-new tangles that I have developed especially for this workbook. You'll see many other tangles throughout the workbook, but these seven are the ones we will break down, step-by-step, and really develop ideas for.

I have taken a very stripped-back approach to this workbook compared to *Zentangle® Untangled*, which I hope will suit beginners on the Zentangle juggernaut, as well as provide some inspiration and guidance to those further into their exploration of the art form. This means that we will take a slow, step-by-step journey through each tangle, working through ideas and refining our skills.

I have not sought to replace the experience you receive in a class taught by a Certified Zentangle Teacher. Learning from a CZT remains the best way to begin and enjoy the Zentangle process. New CZTs all across the world are gaining certification regularly. I hope this workbook will supplement those classes and provide an alternative for those who don't have easy access to a CZT.

The Zentangle® Untangled Workbook is a year long format to help you pace yourself while being introduced to Zentangle basics. I know that you're likely to skip ahead often, and that's perfectly OK. I've organized the book to suit a relaxed pace in keeping with the relaxed nature of Zentangle.

This workbook provides space to practice what you're learning. I strongly encourage you to tangle straight into this book and to not be afraid of "spoiling" anything. Remember, with Zentangle there is no scope for being wrong. Mistakes do not exist here. So, go right ahead—draw directly onto the following pages in pen. For further practice, get yourself a stash of Zentangle tiles or maybe a notebook that you can experiment in.

During the first week you'll practice some basic skills and concepts, such as drawing straight lines and circles, shading and adding color, as well as introducing Zendalas to the mix (Zentangle + mandala = Zendala). You can do these exercises to warm yourself up for the weeks ahead, or you can come back to them as you wish.

We then take each of the seven tangles and spend a week really practicing each element:

Week 1: Step-out process for the tangle
Week 2: Shading the tangle
Week 3: Using color
Week 4: Using the tangle as a page/tile border
Week 5: Creating letterforms
Week 6: Creating shape
Week 7: Zendala fun

Each week includes examples of how to use these elements and provides practice areas for you to have a go. Remember, mine are just suggestions. You are welcome and encouraged to do your own thing!

At the end of the book there are some pages with blank tiles printed onto them for general practice. You may want to use these as you go or as a place to combine your newly acquired talents when you've completed the workbook. That's completely up to you.

So, grab your pen, turn the page and let's get started!

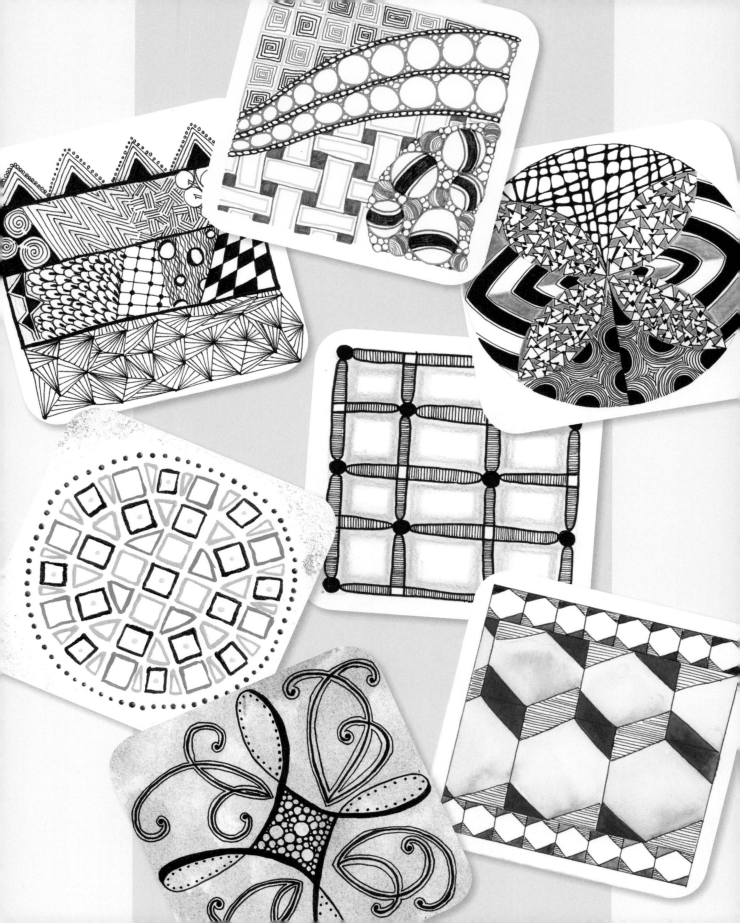

Materials

In *Zentangle® Untangled*, I wrote about the official Zentangle® Kit and the materials used by CZTs. Anyone who has purchased a kit will probably agree this is the best way to start out. The Fabriano paper tiles and the Sakura Pigma Micron pens included in the kit are high quality materials, and if you can buy a kit, I'd encourage you to do so.

With that said, not having a kit or expensive art materials should not stop you from exploring the Zentangle art form. Use whatever supplies you have (including this workbook).

I recommend the Strathmore spiral-bound art journals because they lay flat. I think bristol paper works well. The sketchbooks are relatively inexpensive and are perfect for keeping your tangle practice all in one place.

I used the 5½" x 8" (14cm x 20cm) size when playing with and practicing the new tangles I created for this workbook. It's a handy size to keep in your bag or purse, so it's easy to have it always within reach for whenever an idea comes to mind.

You'll definitely need a graphite pencil. I also think the Faber-Castell Pitt artist pens are great.

But whatever you have in your art supply stash will do to begin with. We don't pass judgment on art supplies here.

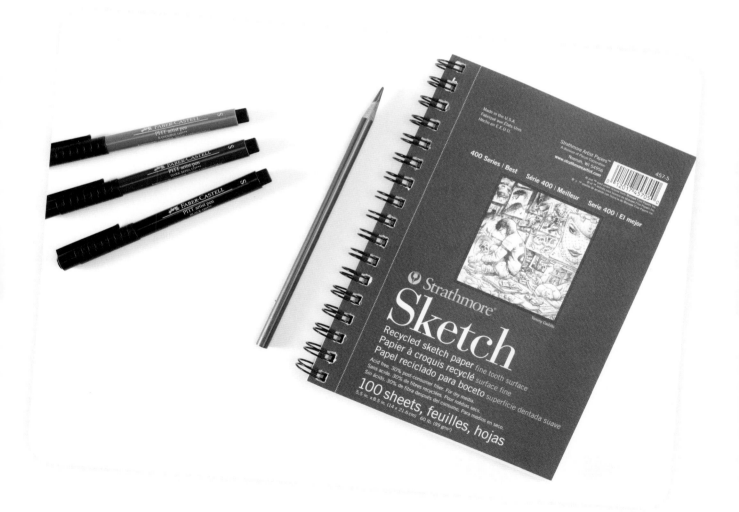

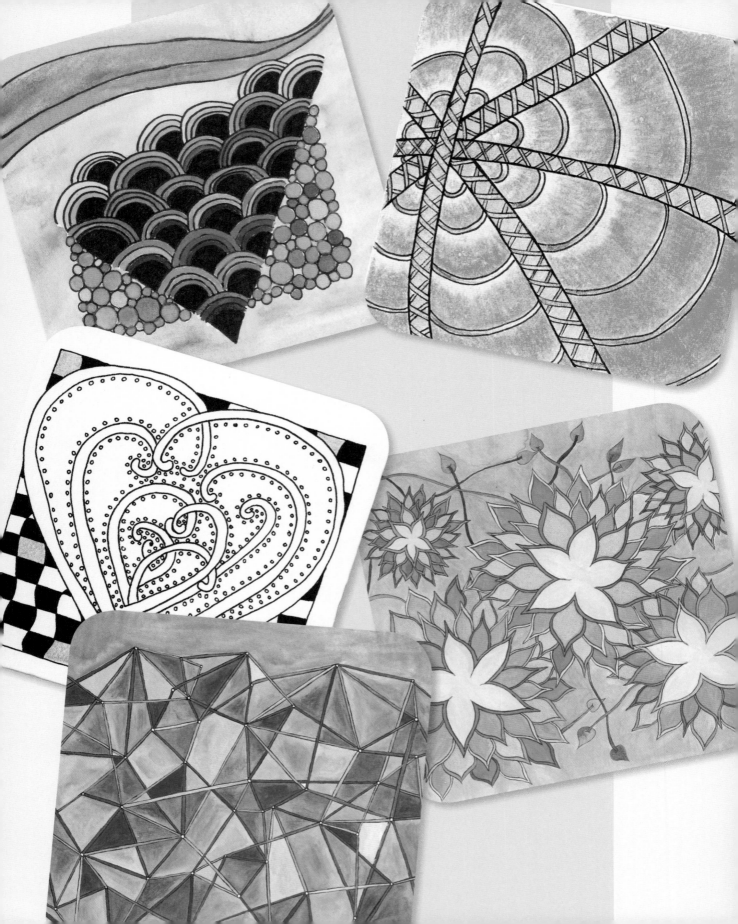

1

WEEK 1
Warm-Up Week

This week is the busiest in the whole workbook, so I want to say up front: don't feel pressured. This is a warm-up week, and it is not as difficult or intimidating as it may look. This is the only week with daily activities. These are to get you started, to get you in the habit of practicing and to introduce some basic concepts. You don't have to do everything if you don't want to or don't have time. You can come back at any time and fill in the gaps.

Remember, there are no rules, no homework and no wrong turns.

I don't introduce a new tangle this week. So play with what you already know, invent your own or look at the vast resources available in *Zentangle® Untangled* or online for ideas.

I cannot emphasize enough that there are no mistakes in Zentangle. Some people demonstrate immediate talent; some take time to practice. With all art forms, practice really is the key. I'm proof of that. When I began art school, I announced at orientation that "I do not draw." You are now reading my second book about Zentangle, a drawing form. Everything requires an open mind, a little practice and the belief that you can succeed. I know you can. Now it's your turn to shine.

DAY 1

Straight Lines and Circles

Ah, if I had a dollar for everytime I have ever heard someone utter the words, "I can't even draw a straight line," I'd be cruising the Caribbean on a fifty-foot yacht right now. Thankfully, I know a secret about how to perfect this very thing, and I can share it with you now: practice. When you repeat something over and over again, you work out how to do it better, more efficiently and in a way that pleases you. Drawing straight lines and circles is no different. Sadly, I don't have all those dollars otherwise I might have to give them back with that little snippet of advice.

You'll see that my lines and circles are not perfect. That is 100 percent fine with me. They're not perfect, but they're not terrible either. Most important, they're mine. That's actually all that matters.

Practice short lines, long ones, wavy ones. Draw tiny circles, then bigger ones. Repeat, repeat, repeat.

You'll see I drew some lines on the third example, then added ruled red lines underneath. I did that to demonstrate the difference between my handiwork and ruled lines. The difference isn't huge—certainly not enough to worry about. It's a handy way to see how straight you can get your lines with some practice.

Visit CreateMixedMedia.com/zentangle-untangled-workbook for extras.

DAY 1 PRACTICE

Use these blank tiles to practice your lines and circles.

DAY 2
Shading

Tangle:
Static

Shading your tangles really does bring them to life. In the example provided, I've used the tangle *Static* to demonstrate shading because I believe it's a great one to show off the differences shaded tangles have.

Let's briefly review shading (I talk about this in *Zentangle® Untangled*).

Shading is where you use a graphite pencil to add shades of gray to your tangles. An HB or 2B pencil will be perfect. Lightly rubbing the pencil in certain spots on your tangle gives the shape and pattern dimension and points of visual interest.

The key to shading is to remember that the gray areas will make the white areas pop up and appear closer to the eye, and the shaded area will look more like background. There's also no right or wrong way to do it. It's whatever appeals to you, the artist.

The example on the left is *Static* without any shading. Still an easy, cute pattern.

The example on the right shows two different ways to shade *Static*. The top half shades in the direction of the static points. It gives the tangle a completely different feel to the unshaded version. This shading makes *Static* feel very three-dimensional, almost as though the peaks and troughs are standing up on the tile.

Additionally, the bottom version of *Static* shades the points, but only in one direction. The graphite has then been smudged. It gives the tangle a ripple effect. This, too, gives a 3-D feel, but different to the one above it.

When shading, remember to use a light hand—a little goes a long way. The areas left unshaded then pop up to the eye more readily, bringing a new element of interest to your tangle.

DAY 2 PRACTICE

Use these tiles to practice ways to shade your tangles. Use *Static* or one of your favorites and see what happens when you try different approaches.

DAY 3
Color and Zentangle

It's fair to say the use of color in Zentangle divides artists. Some love it; some definitely do not. I'm not here to push one approach or another. I quite like both. I will say that color is a great way to explore what different patterns can do, by adding background color, using different color pens or adding highlights. Whether you ultimately use color in your tangles, this is definitely an exercise in getting to know what works for you.

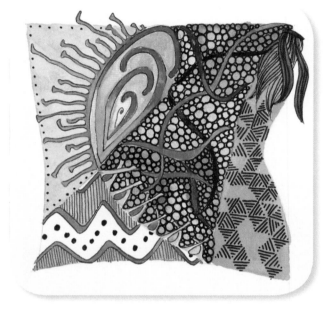

Tangles:

Quabog, Mooka, Mysteria, Raddox, Bumper, Enyshou, Swarm

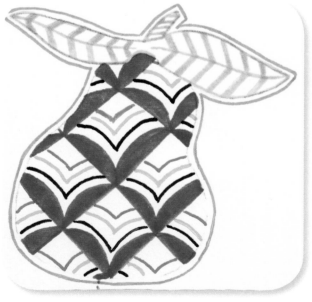

Tangle:

Chillon

DAY 3 PRACTICE

Play with color and Zentangle. Let your concerns float away and just see what happens!

DAY 4
Zentangle Borders

Tangle:
Scarabou

Tangle:
Snail

One of the really great uses for Zentangle is creating borders. These might be borders on tiles (as shown here) or on pages in your journal (you can see some examples of those in *Zentangle® Untangled*). Borders can be plain, shaded or colored; the choice is yours, and you have no limits. If you're someone who doodles in meetings or during class, this might be a fun way to pretty up your notebook, too!

I've provided examples here of some obvious tangles suited to borders, and I have demonstrated adaptations of the tangles featured in this book in later weeks. There is no rule, however, about how you can mix up a design to make it work as a border. We love "tangleations" at Zentangle and want to see you take the basics of what you learn and create something new and exciting with it. What ways can you change a tangle to create a border? What new ideas do you have?

DAY 4 PRACTICE

Use these tiles to practice your border designs, either replicating the examples or making up your own. Think about how your borders can integrate with other tangles.

Letterforms

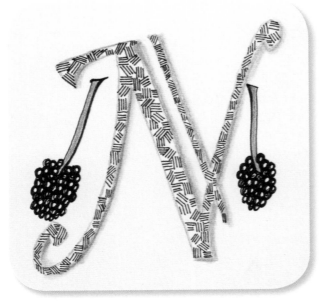

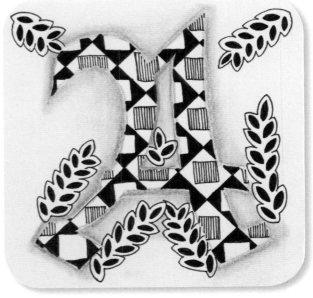

Tangles:

Bronx Cheer, Nekton

Tangles:

Juke, Frondous

Letterforms created with Zentangle are one of my favorite ways to use and practice my patterns. I'm a bit of a lettering geek—yes, typography is fascinating to me—and I was one of those kids who practiced drawing letters in the margins of my diaries and school books.

Creating letterforms with Zentangle is really easy. You can use a pencil to create a letter outline (string) or just go freeform and see where you end up. I've done both, and they can be equally rewarding. I've got a small bias toward classic, old-form lettering because, with the Zentangle-added magic, they look like something from the Middle Ages, when everything was so carefully scribed.

DAY 5 PRACTICE

Use these blank tiles to freehand draw some lettering or maybe trace some letters from books or computer printouts. Try both and see what works for you.

Shape and Zentangle

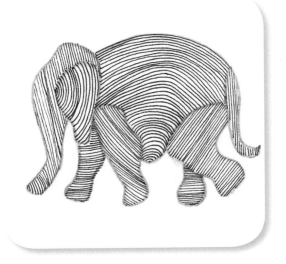

Creating shape with Zentangle seems, well, obvious to me. Does it feel that way to you, too? It seems to me that creating tangles is a lot of fun, but to then use those patterns to create images and shapes just makes sense. In the first tile, I used *Isochor* to create an elephant. Basic, yes, but it gives you a sense of what one tangle can do to achieve an entire shape. The opposite is true for the tile below. Using the outline of a map of Australia, I used a different pattern to demonstrate the borders of each state. I'd love to see this done with the fifty states of the USA.

Tangle:

Isochor (tangleation)

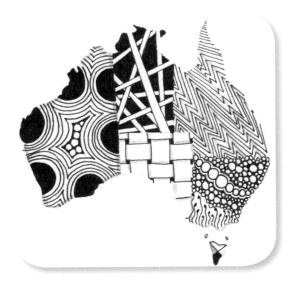

Tangles:

Crescent Moon, Hollibaugh, Static, Fescu, Quipple, W2, Pinch

Tip

This is where we also remind ourselves of "strings" in Zentangle—those pencil lines we use to create areas within the tangle, thereby changing what we're doing (changing direction, changing tangles, changing anything!). When creating shapes, strings can be important, especially as you become familiar with Zentangle.

Think about how shapes can be used in your tangles. Do you want your tangle to develop into a shape organically, or do you want to create a string that makes the shape and tangle within it? Either way is great. Think about the shapes you like; flowers are a favorite of mine. And after you've had some practice, think about ways you can incorporate Zentangle as shape into bigger works. Think big—anything is possible!

DAY 6 PRACTICE

Use a pencil to draw some basic-shaped strings—nothing too detailed, yet. Think about different ways you can use one particular tangle pattern you enjoy, as well as ways to include lots of different patterns. Remember, there are no mistakes!

DAY 7
Zendalas

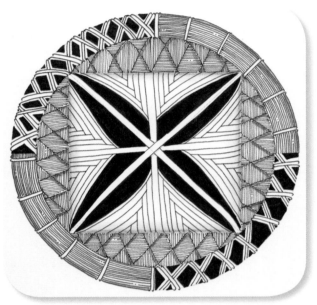

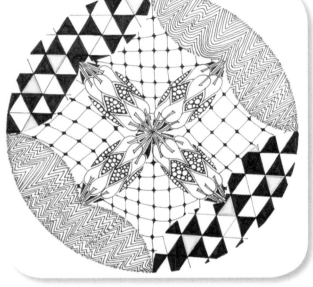

Tangles:

Vega, Zander, Squill, Yincut

Tangles:

Static, Pokeleaf, Florz

The term "Zendala" is a hybrid word combining Zentangle and mandala. Mandalas are circular drawings; it's a Sanskrit word for "circle." The synchronicity between mandala and Zentangle is very obvious, because both are meant to be viewed from any angle. The increasing popularity of Zendalas has been steady, and people who are familiar with mandalas find a very natural progression into Zentangle.

The key to a mandala is balance. With Zendala, that's not quite as important (although to the particular among us—me included—it is lovely to have visual balance). Whatever works for you is fine. Zentangle produces a range of Zendala tiles, or you can find many designs in books or on the Internet. You can also feel free to use the designs I have created here. When you feel comfortable, design your own. It's a lot of fun!

DAY 7 PRACTICE

Here are some circles. Have a go at designing some basic strings. Don't worry if they are not even or balanced; that will come with practice. Think about lines and shapes that complement circles.

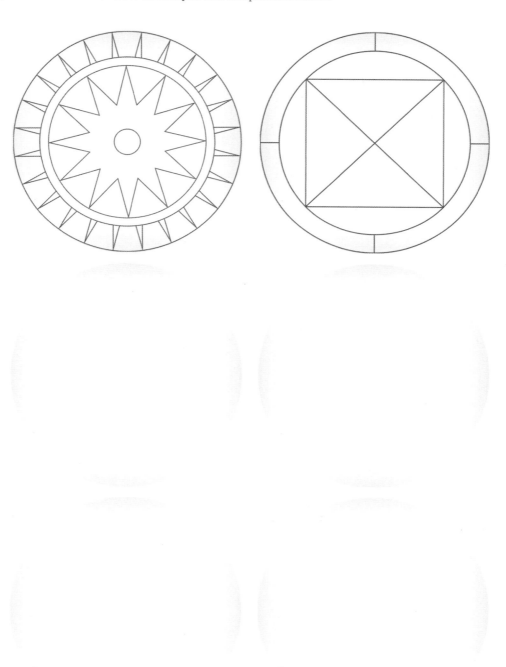

2 *Five-Oh* |
Five-Oh Step-Out

The first tile we're going to focus on in-depth is *Five-Oh*, which I introduced in *Zentangle*®
Untangled. I decided to start with a familiar one so you can develop some quick confidence.

1 Create your pencil border on your Zentangle tile.

2 Draw three long, thin bars in various lengths with rounded edges from one side of the tile. I have chosen to draw left to right, but there is no reason you cannot adapt this to any direction.

3 Draw another fine line around each bar, doubling the bar. Your bars will become wider and rounder at the ends as you add more lines.

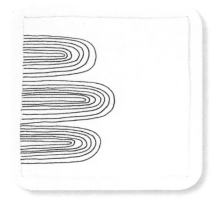

4 Continue to add more lines until each wave meets up.

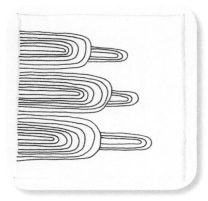

5 Once each wave has connected, start a new wave on the end of the existing waves. These, too, should be various lengths.

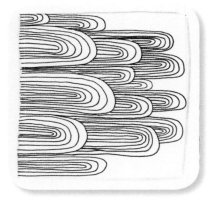

6 Continue building new waves at various heights until you feel that the waves are complete.

Visit CreateMixedMedia.com/zentangle-untangled-workbook for extras.

FIVE-OH PRACTICE

Use this space to practice *Five-Oh*. Try it alone and with some other tangles. See what works for you. Get your hula on!

Five-Oh Shading

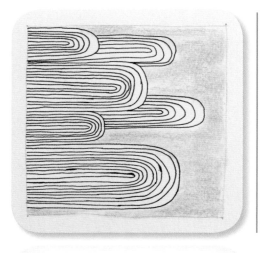

Shading *Five-Oh* can be quite an adventure. There is no wrong way to do so; you can shade around it or from within. You may even come up with something not shown here that you like. The key is to make the white space stand out, so try not to shade something you want noticed—shade around it instead.

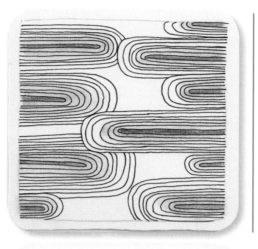

Use these tiles to practice shading *Five-Oh*. I've shown you two variations on shading. What others can you think of? Try whatever comes to mind, and see the tangle come to life. And if you don't like how a particular shading exercise looks, *keep it*—as a reminder of what not to repeat!

Five-Oh Color

I have to confess that I can think of many ways to use color with *Five-Oh*, but I limited myself to just two this time around. I'd love to see what other ideas *you* can come up with. Think about colored pens, but also the color between the lines.

Tangles:
Five-Oh, Pokeroot, Ahh, Fescu

Use these tiles to experiment with color using *Five-Oh*. How many color variations can you think of? Are there particular colors you think are suited to this tangle?

Tangle:
Five-Oh

Five-Oh Borders

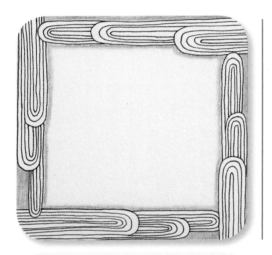

Five-Oh is a really fun way to create borders for your Zentangle tile, and it's quite flexible in its use. You can also create "waves" around the edges. There really is much to be explored here.

My advice is to simply pick a starting point and go for it. Make some big waves, make some smaller ones.

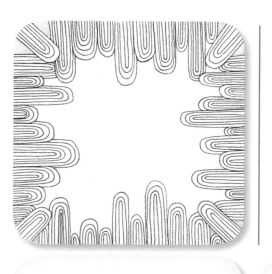

Use these tiles to create some *Five-Oh* inspired borders. What other tangles can you use to create a visually interesting piece?

Five-Oh Letterforms

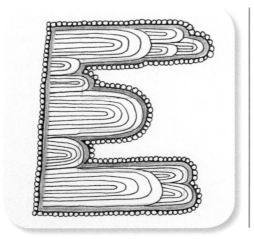

With the waves of *Five-Oh*, maybe the letter "E" was an obvious choice to use for a letterform. I thought about whether I should change some of the wave directions too, so they'd look like they were crashing into each other. Maybe that's something you can try.

Tangle:
Five-Oh

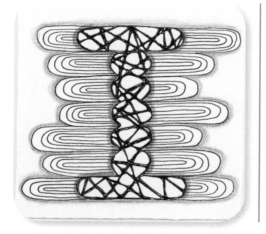

Five-Oh also makes an ideal tangle for the outline of a letterform, like the letter "I." The shape of the "I" was such that the waves extending out seemed perfect. What other letterforms can you make work with *Five-Oh*? Put your best Tim Gunn thinking caps on!

Letterforms are a great way to explore the possibilities of Zentangle. Make use of these letters and then design some of your own. I can't wait to see your creations!

Five-Oh Shapes

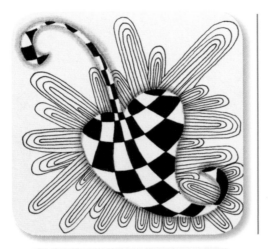

OK, small gratuitous chest beating here, but I kind of really love this tangle. Apart from the groovy shape (hello, clip art!), it just *worked*. There are any number of ways this shape could have popped, but to me, the *Five-Oh* around the edges of the flourish is perfect. It gives a great sense of shape and allows the *Knightsbridge* shape to really feel three-dimensional.

Tangles:

Five-Oh, Knightsbridge

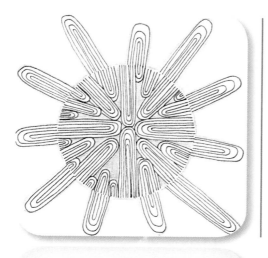

Tangle:

Five-Oh

Five-Oh can also create the overall shape of a tangle. This "sun" is a relatively simple way to demonstrate what *Five-Oh* can do, but I know there are lots of really imaginative ways, too. Let me see them!

Use these basic shapes as starting points for creating shape with Zentangle. After a while, you won't need the strings; your natural instinct will tell you what works. These are a good beginner's point, though.

Five-Oh Zendalas

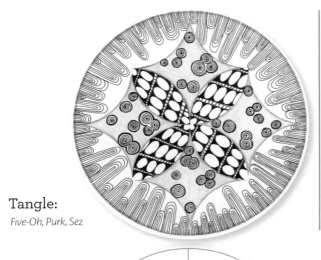

Tangle:
Five-Oh, Purk, Sez

I'm a little bit excited about these Zendalas because they really bring *Five-Oh* to life. Not only can *Five-Oh* be used as a quasi-border (like the example here), but it can become a real focal point (as seen opposite). Is it just me, or do these *Five-Oh* Zendalas feel a little futuristic?

Zendalas don't have to have the balance that mandalas do, so play with some of the strings and really get a feel for how *Five-Oh* can be interpreted "in the round."

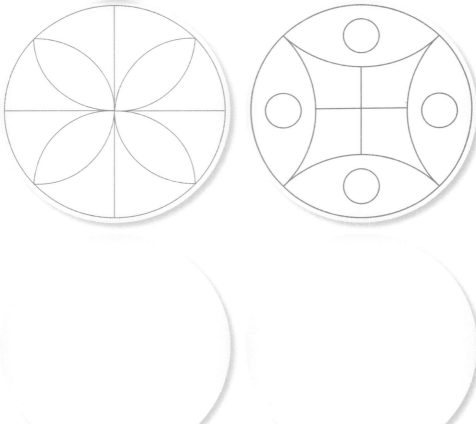

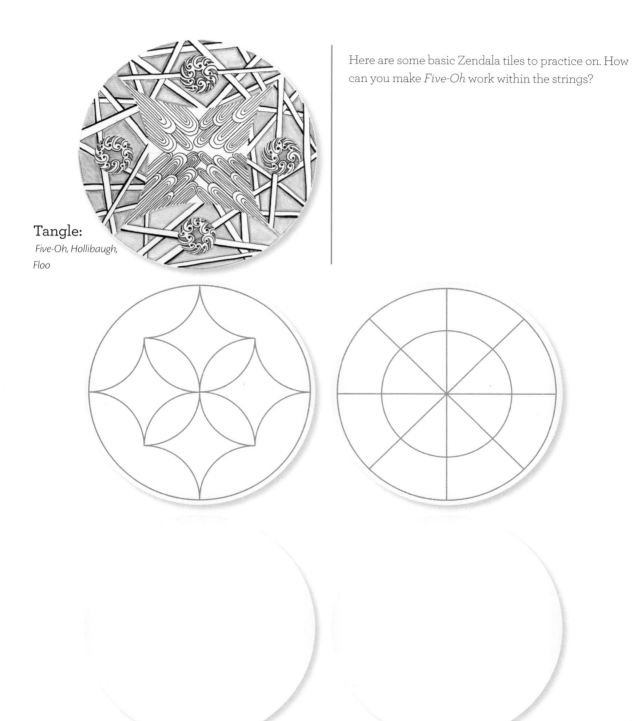

Tangle:
Five-Oh, Hollibaugh, Floo

Here are some basic Zendala tiles to practice on. How can you make *Five-Oh* work within the strings?

3 *Blossom* | WEEK 9
Blossom Step-Out

Blossom is a really easy tangle and also an incredibly flexible one. Once you have the single shape, what you do next is limited only by your imagination. Great as a stand-alone tangle or to add some flair to your existing work, let's have a go.

1 Draw a crescent-shaped line; it needs a curve but not a semi-circle appearance.

2 Add two small stems near the top (you choose which end you want to be the top of the stem). Then add black filled-in circles to the ends, like a blossom would appear.

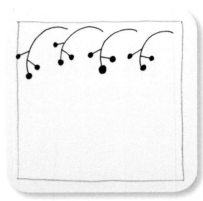

3 Repeat steps 1 and 2 across the tile; about four across work nicely.

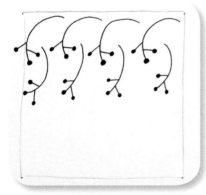

4 Start a new line, but change the direction of the curve and start about halfway down the last curve.

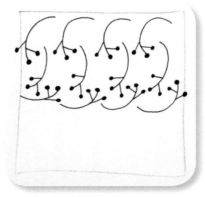

5 Add a new line, returning to the first curve direction but changing the starting point. The goal is to build up a flowery cover.

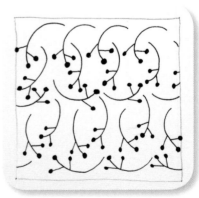

6 Complete lines of *Blossom* to suit your taste and shape.

Visit CreateMixedMedia.com/zentangle-untangled-workbook for extras.

BLOSSOM PRACTICE

Use these tiles to practice *Blossom* and experiment with ways you'd like to use it. Also think about ways to use *Blossom* as a highlight in other tangles you create.

Blossom Shading

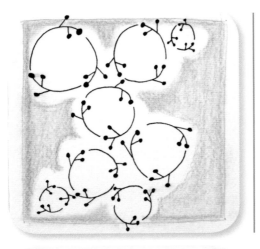

Blossom is not your regular tangle and can seem complicated to shade. In fact, it is not even necessary to shade it if you don't want to. However, in the spirit of "shading enabling," let's look at some ways you can shade *Blossom*.

You can shade the white areas near *Blossom*. I've shown this in the example; this accentuates the shape of *Blossom* (if that's your intent). I used *Blossom* to create circles of different sizes and then shaded the white space to draw the eye to those circles.

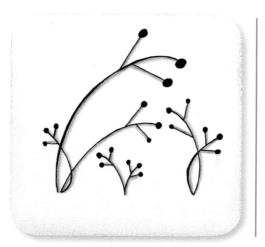

In the second example, I've applied the shading principle directly to the *Blossom* stems as well as around the edge of the tile. I chose to simply shade lightly on the right-hand side of the stem, regardless of the direction of the stem. I liked how that turned out, too.

Use these tiles to continue playing with *Blossom* and try different shading techniques.

Blossom Color

Because of the floral nature of *Blossom*, it works well with other nature-inspired tangles. This is great for me because I think my flower-art-loving credentials are well established! This also bodes well for using color in Zentangle. *Blossom* can be any color, or maybe many colors in one tangle. In the tangle here, I've used orange pen to show the tangle *Cyme* with *Blossom*—they complement each other well.

Tangles:

Blossom, Cyme

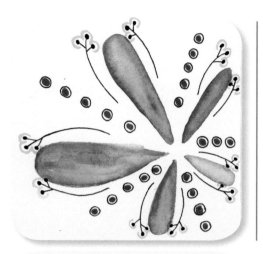

Here, I played with some new watercolor paints and let the design reveal itself. When I went back to it later, I felt the colors were enough and not too many tangles were needed—and *Blossom* worked well.

Can you think of other ways to use *Blossom* as a color accent?

Use these tiles to explore the possibilities of color with *Blossom* and how the two can work together.

Tangles:

Blossom, Sez (tangleation)

Blossom Borders

The relative simplicity of *Blossom* and the lack of space it needs makes *Blossom* a really interesting border tangle. I think those girly-girls among us will say we've been doing this type of decoration around notebook pages for years (tell me I'm not the only one!?), and that is definitely where the inspiration for this type of border comes from.

The examples show how to use *Blossom* around the edges of the tile but also how to use it so it becomes part of the overall design. I think there are definitely opportunities for development here. *Blossom* can be used so many ways. Which way suits your Zentangle style?

Use these tiles to practice using *Blossom* as a border. Try out my suggestions, and then give your own ideas a chance to come to life.

Tangles:

Blossom, Sez (tangleation)

Blossom Letterforms

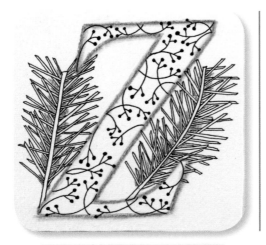

Letterforms and manuscripts really do lend themselves to Zentangle like nothing else. It's possible that, of all the tangles I've created in this book, *Blossom* might be the one that emphasizes that point best. Because of its simplicity, it can be used to create the shape of the letter (as shown in the letter "Z" example), but it can also be used with great effect around a letter (as shown in the "J" example). It just works, don't you think?

Tangles:

Blossom, Verdigogh

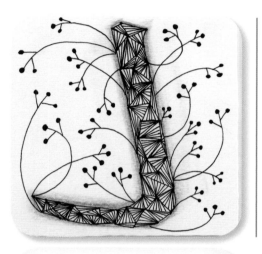

One of the things I like about "J" is that using *Munchin* with *Blossom* really shows how an organic tangle can work well with a more abstract one.

Time to get your floral on, tanglers. Use these letterforms as a way to practice *Blossom*. Create a beautiful, original page of (flower) power!

Tangles:

Blossom, Munchin

Blossom Shapes

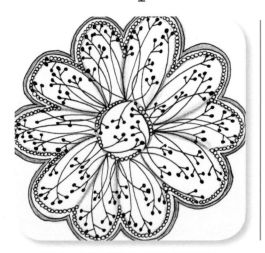

Shape is a really interesting concept when taken in the context of *Blossom*. It's not a tangle that creates shape easily— but it can definitely be done, as I have shown here.

Tangle:
Blossom

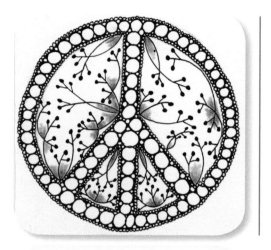

Whether an accent to a shape or defining the shape itself, *Blossom* has the flexibility to be what you need it to be. By all means, play with it and vary it as needed. It's designed to work that way.

Use these basic shapes to play with *Blossom*, changing elements as you need to make it work for you. Look at what other tangles you can combine with this tangle to great effect.

Tangles:

Blossom, Onamato (tangleation)

Blossom Zendalas

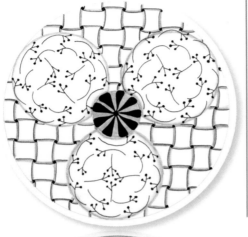

Tangles:
Blossom, W2

The rounded shape of *Blossom* and its natural flexibility means that when applying it to Zendala, it will adapt easily to the style. Given that Zendalas themselves can be both cyclical and not, *Blossom* can work as a repeat or as a single element. How you use it is limited only to your imagination and where your pen takes you!

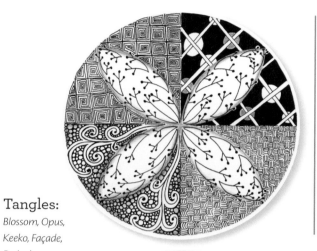

Tangles:

*Blossom, Opus,
Keeko, Façade,
Emingle*

These Zendala tiles are a great way to practice using *Blossom* in the Zendala style, to play some more with what tangles go nicely with it and to create *Blossom* "tangleation."

You can create strings in many ways with Zendala, but more often than not, keeping balance is essential. This means starting in the center and working outward. You can, of course, experiment in any way you like, but I think you'll like the results of starting in the middle.

Look at the Zendalas I've included in this workbook that are prestrung. They all have a center point.

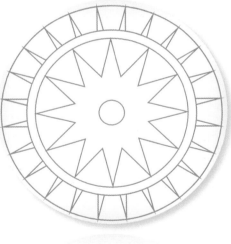

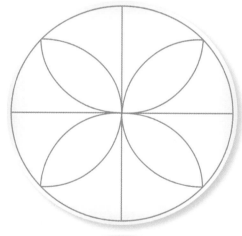

4 *Honeycomb*

I first introduced *Honeycomb* to you in *Zentangle® Untangled,* and I had a really positive response to it. I decided to include it here again to add some further ideas on how to use it as well as introduce it to new readers.

1 Create a pencil border on your tile.

2 Draw evenly spaced lines across the tile—about five should fit nicely. Then turn your tile 90 degrees and draw lines across to give your tile a "square brick" appearance.

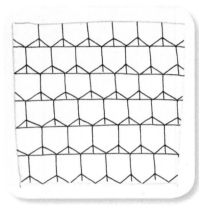

3 Across each row, connect the bottom third of each vertical line to the corners of the square beneath it. This will look like roofs on houses. Do this to all the squares.

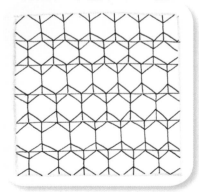

4 Turn the tile 180 degrees. Repeat step 3. You'll see a zigzag effect take shape across your tile.

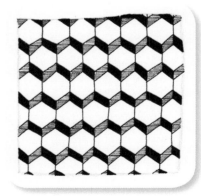

5 Fill in the zigzag effect as desired. My suggestion is to solidly color one direction and put a pattern (I've used fine lines) in the other.

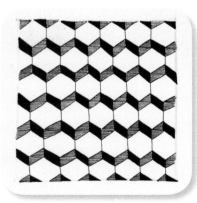

6 Shade as desired. I suggest choosing one part of each shape and shade that area in each hexagon.

HONEYCOMB PRACTICE

Use these tiles to practice *Honeycomb*. It looks complicated, but it isn't. You just need to concentrate until it comes instinctively to you.

Honeycomb Shading

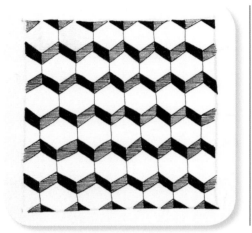

The shading options on *Honeycomb* are varied, but the trick is to be subtle with it in order to get the different looks *Honeycomb* can provide. In this example, I shaded the lined areas of the 'comb—lightly, so as not to overpower the lines or the solid black sections next to them. In the example on the next page, I instead shaded the left side of the white hexagon shape. It's subtle, but it's there, and it depicts light shining from a particular direction.

There are many options for *Honeycomb* shading. I'd love to see some of the experiments you make with it.

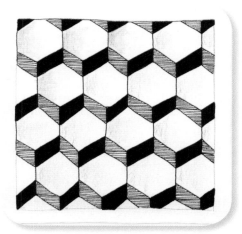

Use these tiles to try out different shading techniques for *Honeycomb*. This will help you identify the shading you like best for this particular tangle.

Honeycomb Color

Tangle:
Honeycomb
(watercolor
paint)

Honeycomb is a tangle that really gives tangle enthusiasts color options. It may be the background color that you change up (like I have done in the example on this page), or you may prefer to assign colors to particular elements of the tangle (as I've done opposite). These are not the only options, of course. For the particularly color happy among us, you might want to make each hexagon a different color. You might use different colored pens for each section—the choices are limitless. While I've kept it basic here, there is nothing to keep you from really exploring color stories using *Honeycomb*.

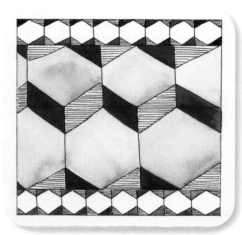

Get out some pens and colors, and play with *Honeycomb* here. Remember, these practice pages are for play and trying new things, so go wild!

You'll also notice I've used different sizes of the *Honeycomb* tangle. This is a tangleation, and I encourage you to try it and any others you can think of.

Tangle:

Honeycomb (watercolor paint)

Honeycomb Borders

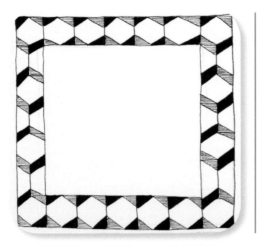

I was a little worried initially that using *Honeycomb* as a border would be (1) a little predictable, and (2) a little too simple, even for beginners. Tell that to the half dozen tiles that went to art heaven while I tried to "make it work!" In the example on this page, the tricky part was getting the top and bottom lines even so the sidebar areas would meet up correctly. It wasn't quite as easy as it looks, and if you need to use your pencil to lightly guide yourself, you have my permission!

This second example is actually one large *Honeycomb*. It's a slightly different approach, but if you did it this way, you could then draw a string inside the hexagon and continue from there. Why not give it a try?

Your mission, should you choose to accept it, is to create some *Honeycomb*-inspired borders. Definitely try to do it without gridlines initially, and see what other variations of this type of border you can dream up.

Honeycomb Letterforms

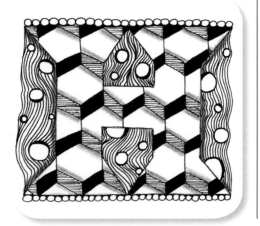

"H" for *Honeycomb*. Too much? I hope not. I thought it actually worked nicely. *Honeycomb* the tangle, being a nice, linear tangle, works well with the uppercase "H." I chose to contrast this with the second example, "D," which is a curved letter (opposite). You'll agree; *Honeycomb* defines its outline well here, too. *Honeycomb* can be the letterform, or it can outline it. Either way, it's a great tangle for tangling your alphabet.

Tangles:

Honeycomb, Nipa

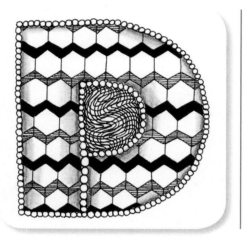

Explore the possibilities of *Honeycomb* as a letter-forming tangle below. Use *Honeycomb* in a variety of sizes, too. If you can manage to keep the tangle small, it has a terrific effect.

Tangles:
Honeycomb, Orlique

Honeycomb Shapes

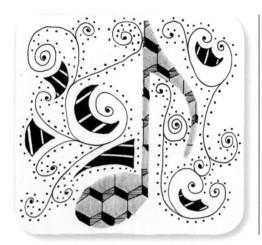

Much like we did last week, I want you to continue manipulating *Honeycomb* into shapes. Last week we tackled letterforms; this week it's general shapes. In the first example, I deliberately chose a musical note so I could use the narrow stem of the note, showing that it's possible to work a tangle like *Honeycomb* into an abstract shape, not requiring the whole *Honeycomb* form.

Tangles:

Honeycomb, Ibex

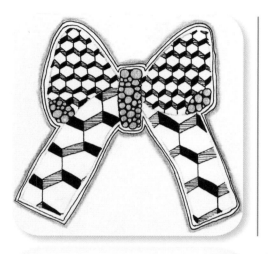

Alternatively, in the second example of the bow, I've used *Honeycomb* across all sections of the shape, demonstrating the effect of using the same tangle at different sizings.

Keep exploring *Honeycomb* as a shape-builder using these as a guide. Use different sizes and directions to create points of difference, and remember that your shading will really come into play with this tangle, too.

Tangles:

Honeycomb, Tipple

Honeycomb Zendalas

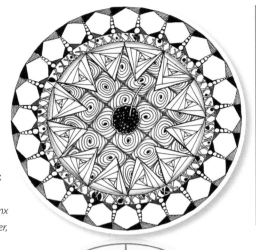

Tangles:
Honeycomb, Paradox, Bronx Cheer, Bumper, Tipple

At the risk of a little more chest beating, I have really loved using *Honeycomb* as a Zendala tangle. It comes up a treat. What I really wanted to show you was that, despite its linear nature, *Honeycomb* could adapt to the circular Zendala shape. In the example here, I used it around the outer edge of the Zendala. I had to manipulate the shape of the hexagon ever so slightly, but it works. Definitely try that out. It's easy to do with great effect.

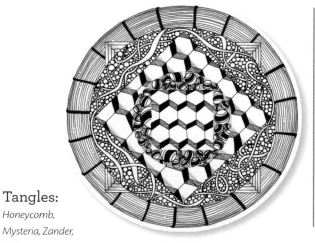

Tangles:
Honeycomb,
Mysteria, Zander,
Jetties

In the second example, the Zendala strings were layers of squares, one on top of another. The two inner squares were begging to be *Honeycomb*'ed, with the circular *Jetties* tangle between the layers. I love the way that turned out—unplanned but rocking the Zendala.

Here's your chance to rock your Zendala with *Honeycomb*. There are so many possibilities, and I know you, the tangler, will totally show me up on this one. I believe in you—now *go*!

5 *Stixnstonez*

Stixnstonez is a really easy tangle I designed to create a grid appearance. It can be left alone, or you can use the grid to tangle the inside of it—it's up to you. But we'll get to that later.

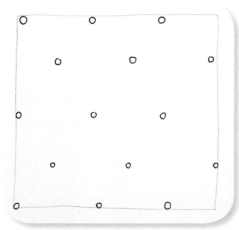

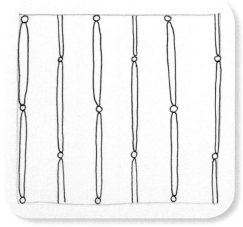

1 Create small circles in a straight line across your tile. Repeat at the halfway point on the next line, as shown. Try to keep the spacing as even as possible, both across the tile and down.

2 Connect the circles with thin, sausage-like lines. Do this either vertically or horizontally first and complete all the lines.

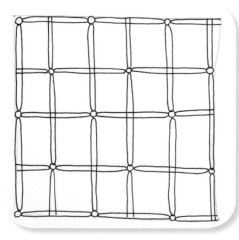

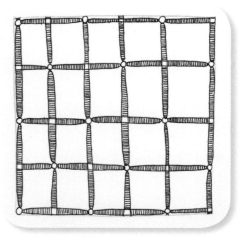

3 Turn your tile 90 degrees and repeat step 2.

4 Draw small, fine lines across the "sausages" to give color and dimension. Simple!

STIXNSTONEZ PRACTICE

Now it's your turn. Use these tiles to practice *Stixnstonez*. It's really easy once you get the hang of it. Don't be afraid of making mistakes or changing elements to suit your own style.

Stixnstonez Shading

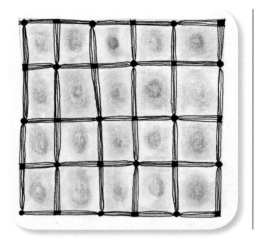

Stixnstonez is a really easy tangle to shade, simply because there are so many options. Really, anything goes, but consistency is the key here. In this example, I created heavy pencil markings in the middle of each square and then used my finger to "push" the color to the edges. If you look carefully you might see some partial fingerprints!

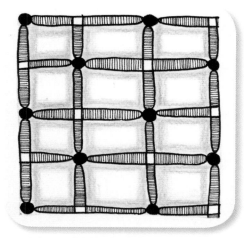

In the example here, I've lightly shaded the outer edges of the squares (a reverse of the first example in some ways). There is no reason that you shouldn't shade the tangle itself, too—perhaps the circles (the first step in the tangle creation)—or create gradients across the whole tangle.

Keep practicing *Stixnstonez* here, now adding shading options. Try as many variances as you can think of.

Stixnstonez Color

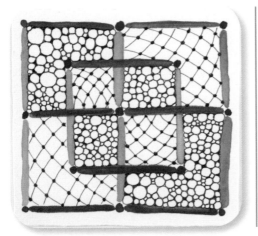

The color examples I've created here for *Stixnstonez* are not super different, and I've done that deliberately. I've used different colors in each example as well as variations on how you can make *Stixnstonez* work for you. I've also used the example here to show how you can incorporate other tangles into *Stixnstonez*. The tangle itself is in watercolor, the inner tangles in Micron pen.

Tangles:

Stixnstonez, Tipple, Florz

This example is also watercolor and is a simpler version, with *Verdigogh* as an accent tangle. It shows how the crisscrossing of the grids can be done with color.

Another option might be to create *Stixnstonez* as you normally might and color the squares differently. A little *Saturday Night Fever* in your Zentangle collection?

Here's your chance to really explore color options with *Stixnstonez*. There are so many choices—which ones will you make?

Tangles:

Stixnstonez, Verdigogh

Stixnstonez Borders

The grid nature of *Stixnstonez* means that it lends itself to being a tangle that you can create tile or journal page borders from. In this example, I drew two light pencil borders, leaving about a $1/2$" (13mm) gap between the lines. This gave me a good guide for the size of the grid. It is imperfect in its gaps, but I am completely OK with that. Hopefully you are, too.

In this example, I stripped the tangle right back to its essential elements—the lines. I put small circles in the corners of the tile and created small squares at the midway points to emulate the crossover you'd normally have. You don't have to do it this way, but it's something to consider.

How many different borders can you design using *Stixnstonez* as your starting point? Practice and try some new ideas here.

Stixnstonez Letterforms

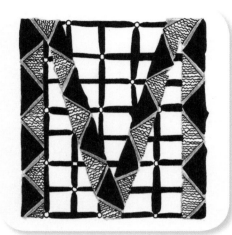

One of the real advantages of *Stixnstonez* is that it works both as a focal tangle and as a great background tangle. Many people tell me that they want to create a tangle but then fill in the white space around it, particularly for things like cards and letterforms. So I've demonstrated here how both can work. In the first example, the "M" is a tangle called *Knase,* and the background uses *Stixnstonez.* What I like is that *Stixnstonez* acts as an unofficial grid, meaning it can guide the tangle in the "M" if balance is your key.

Tangles:

Stixnstonez, Knase

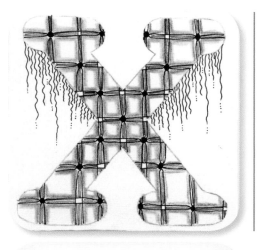

It also works as the shape builder in the "X," shown here, although you can see the squares are a little less even in this one. The good news? There are no mistakes in Zentangle, so the unevenness doesn't matter a bit!

Use these letterforms to practice using *Stixnstonez* as both a focal and a background tangle, and see which letters you feel it works well with.

Tangles:

Stixnstonez, Fescu

Stixnstonez Shapes

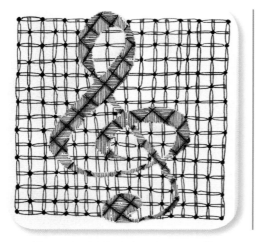

Choosing *Stixnstonez* for shapes really continues last week's exercise of letterforms. However, because of the grid-nature of *Stixnstonez*, I deliberately chose shapes that are curvy or uneven in nature so you can see how it can be used that way, too.

In the treble clef example, obviously the *Stixnstonez* was used as the background. Applying it evenly behind the curved nature of the treble clef shape, however, took some thinking and concentration—and even so, it's not completely even.

Tangles:

Stixnstonez, Yincut

The vintage TV shape is hand drawn. *Stixnstonez* is used on the screen; I simply turned the tangle to a diagonal angle. I also used the *Stixnstonez* basic concept for the dials on the TV.

Use these shapes to practice *Stixnstonez* and really challenge yourself to use it in a more complex way. You might find the results are better than you expect.

Tangles:

Stixnstonez, Tipple, Crescent Moon

Tip

If you're looking for shapes to draw, look inside kids' books, on the Internet and at photographs you might have. There are shapes everywhere you look! Look for basic shapes and outlines, and add the points of interest through your tangles instead of through the shape itself.

Stixnstonez Zendalas

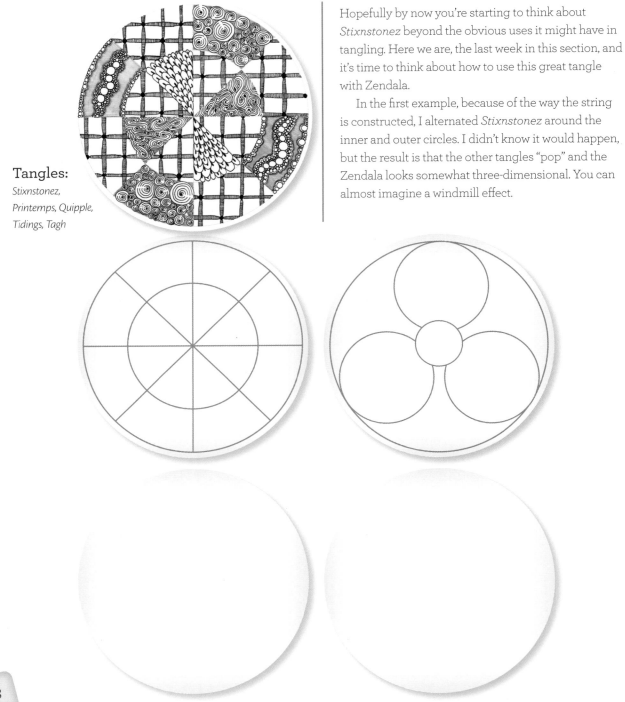

Tangles:

*Stixnstonez,
Printemps, Quipple,
Tidings, Tagh*

Hopefully by now you're starting to think about *Stixnstonez* beyond the obvious uses it might have in tangling. Here we are, the last week in this section, and it's time to think about how to use this great tangle with Zendala.

In the first example, because of the way the string is constructed, I alternated *Stixnstonez* around the inner and outer circles. I didn't know it would happen, but the result is that the other tangles "pop" and the Zendala looks somewhat three-dimensional. You can almost imagine a windmill effect.

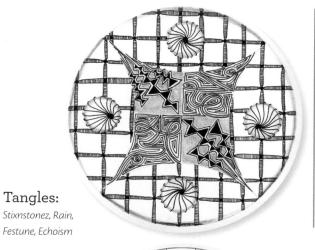

Tangles:
Stixnstonez, Rain,
Festune, Echoism

I deliberately used *Stixnstonez* as the background in this example, but the three-dimensional appearance came through here, too. Some of that also comes from the outer shading.

Use these Zendala tiles to practice using *Stixnstonez* in the round and think about how you, too, can achieve the three-dimensional look.

6 *Trimee* | WEEK 30
Trimee Step-Out

Trimee is a really simple tangle I created with randomness in mind. So many tangles rely on a repetitive pattern that is carefully constructed. *Trimee* is not one of those tangles. It's a repetitive pattern, but you can take it anywhere.

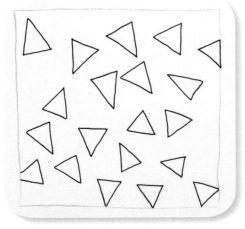

1 Randomly place triangles within the area you wish to tangle. They can be the same size or different sizes. (I've kept them the same size for this example just to make it a little easier.)

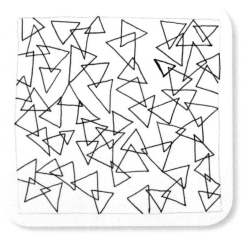

2 Continue randomly placing triangles, overlapping some of the edges. You want to create links, but not too much crossover.

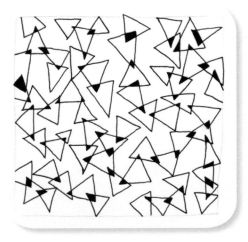

3 Color in the overlapping areas inside of the triangles. Look carefully at my example to see what I mean. Simple, flexible, random. Now it's your turn!

Visit CreateMixedMedia.com/zentangle-untangled-workbook for extras.

TRIMEE PRACTICE

Use these tiles to practice *Trimee*. Practice with same-size triangles as well as differing sizes. Get a feel for it here so you can start changing things up in the weeks to follow.

Trimee Shading

Because of *Trimee*'s randomness, you can also shade it creatively. I've provided some simple examples. In the first example, I shaded inside the triangles.

In the second example, I shaded the outside of the tile to give the section some shape (especially when tangling inside a string).

These are the simplest ideas, but there are so many possibilities. What about shading around the triangles? Or inside randomly chosen triangles?

There are many variations for shading *Trimee*. Don't be afraid to try new things.

Use this space to try different shading techniques. Use the grade of your pencil to lightly and more heavily shade, too, for something a bit different.

Trimee Color

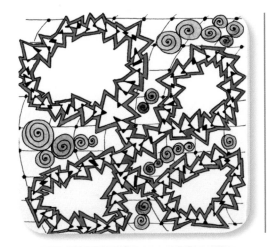

Just as there are a million shading options for *Trimee*, color presents a new range of opportunities, too. In this example, I used the concept of *Trimee* to create a shape and colored the black crossover parts. I then created an aura around the outer and inner lines of the larger shape and colored the aura red. I was thrilled with the result. It gave definition to the larger shape but also really emphasized the stark black and white of the *Trimee* itself.

Tangles:

Trimee, Florz

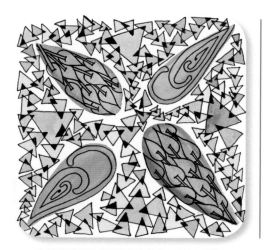

The second example borrows the idea I floated in the last exercise. Instead of shading random triangles, I colored them to create a background. I've used the *Mooka* tangle as an alternate to a string here; it breaks the tile up the way a string normally might. Don't forget to use strings where and when you want to.

Create some *Trimee* tangles here and then add color. Whether you color it entirely or choose to highlight some parts over others, the choices are endless, and you can have a lot of fun with it.

Tangles:

Trimee, Pokeleaf, Mooka

Trimee Borders

When it comes to borders on Zentangle tiles or in journals, *Trimee* keeps it pretty simple. The examples I've created here are deliberately simple, using the *Trimee* concept in a simple way (all triangles pointing inward in the example opposite) and in more random directions.

The key to using *Trimee* effectively as a border is in how you shade or color it. This is where your earlier experiments will come in handy. You'll know what works for you and how to manipulate the shading in a way that is pleasing to you.

You might also come up with some alternative ways to create borders using *Trimee*. Don't forget to think about what other tangles you could combine with it to create something special.

Have some fun using *Trimee* as a border and trying new ways to make it interesting and innovative.

Trimee Letterforms

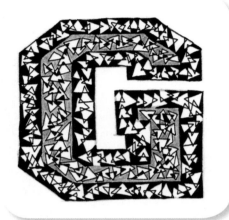

As much as I found *Trimee* a little challenging as a border tangle, using it as a letterform tangle came very easily to me. These designs, I think, really show off how terrific *Trimee* can be. The "G" letterform is a stencil-style letter, and I used the inner and outer shapes to reverse the coloring of the *Trimee*. I colored the outer section around the triangles, instead of the overlaps. The traditional way of creating *Trimee* is on the inside, but I did a solid shading around the triangles—and I think it turned out really well.

Tangle:

Trimee

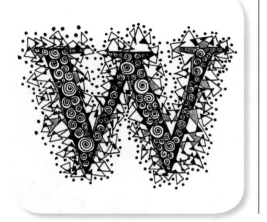

Trimee is used differently in the "W" here. It floats around the "W" shape, and with the shading and the dots I added, this is a really whimsical and fun letterform. Letterforms don't have to be old-fashioned—especially in your art journals. Use your tangles to really *play* with lettering!

Letterforms really are a lot of fun, and *Trimee* is flexible enough to work in a variety of ways. Use this area to play with it and get a sense of what you can do.

Tangles:
Trimee, Printemps

Trimee Shapes

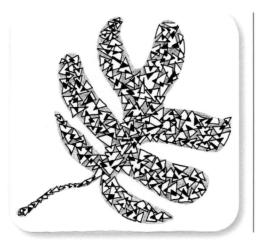

Continuing from last week's examples of letterforms, this week we turn to other shapes we can apply *Trimee* to so we can create wonderful shapes within our tangles.

The first shape, the leaf, is a great example. Using *Trimee* and then shading the outer areas to complete the shape gives the leaf some dimension. You almost want to run your fingertips over the leaf to see if it has the texture a real leaf has!

Tangle:

Trimee

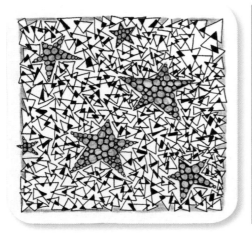

The second example is a background around the star shapes within the tile. This one could probably use some color to make it really pop, but you see the stars and *Trimee* continues the angular feel of those.

Think about how shapes can be manipulated with a random, flexible tangle like *Trimee*, and try out a few ideas. You'll soon discover what works and how best to create shapes.

Tangles:
Trimee, Tipple

Trimee Zendalas

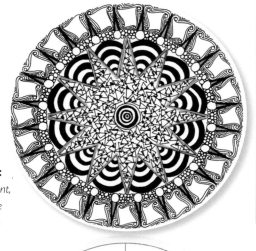

Tangles:
Trimee, Cadent, Tipple, Drupe (tangleation)

I think I have saved the best *Trimee* examples for last here because Zendala and *Trimee* work really well together. Why? Because of *Trimee*'s flexibility. It can work in any space.

It wasn't intentional, but I think this example is a little Tim Burton inspired—*Trimee* being just a little bit crazy like Burton's films! With the combination of the other tangles, *Trimee* looks like it was meant to be, just for that Zendala.

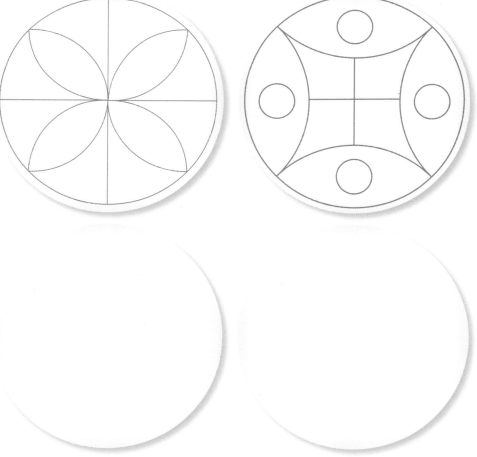

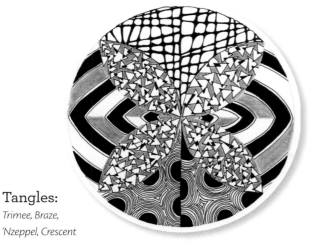

The second example is simpler, but still has the consistency of the *Trimee* leaves in the center of the Zendala.

There are so many possibilities for *Trimee*, and I know you will find many varied and interesting ways to use it. Embrace its whimsical randomness.

Use this space to create beautiful, modern whimsy Zendalas with *Trimee*. You'll love the results!

Tangles:

Trimee, Braze, 'Nzeppel, Crescent Moon

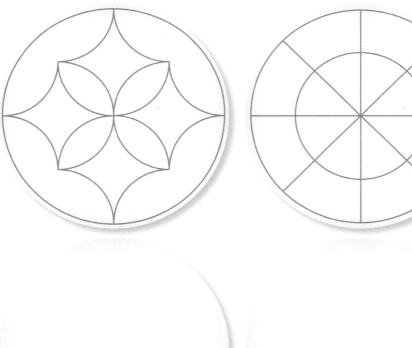

7 *Starfish* | WEEK 37
Starfish Step-Out

Starfish is a relatively simple and very adaptable tangle that, once you get the initial shape happening, is a great white-space filler or a central-focus tangle. The best part is that, although I demonstrate a range of ways to give dimension to *Starfish*, you're only limited by your own ideas.

1 Create a five-point pentagon using curved lines inward. These don't need to be perfectly even, but try to keep them relatively even.

2 Connect two points of the pentagon using a cone shape.

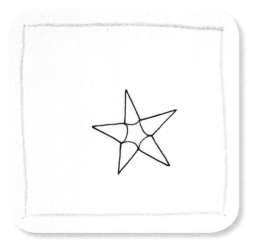

3 Repeat step 2 until you have a five-point star shape.

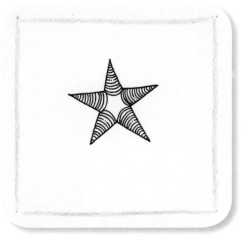

4 Fill the arms of the starfish with lines. I used curved lines to run parallel with the original pentagon shape.

STARFISH PRACTICE

Use these tiles to practice *Starfish*. Getting the central shape in proportion is the key—of course, only if you want proportion!

Starfish Shading

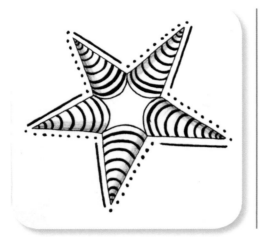

Shading *Starfish* is really easy because there's no way you can get it wrong. Your shading choices really depend on what patterns you give to the star tentacles and what you think might best accentuate those.

In this example, I chose to gently shade the same side of each star point. This gives each point some curve, combined with the initial lines I drew in pen.

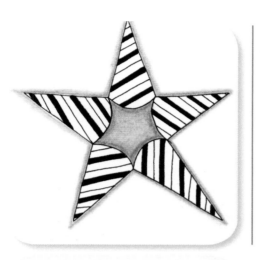

In the second example, I shaded the center of the star as well as the outside lines. Shading both areas makes the star really pop off the page. Remember that shading makes the white space around it appear closer than the shaded part. There are endless possibilities for shading *Starfish*.

Use these tiles to explore shading options with *Starfish*. You may find you need more space to try new combinations. Think about the tangle you've used in the star points and how shading might best complement that as well as the larger *Starfish* tangle.

Starfish Color

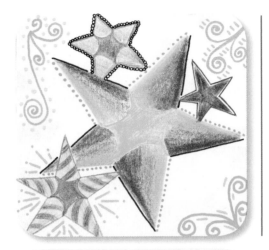

Starfish is a tangle for the color happy among us. Because of the various possibilities of patterns in the star points, color can be used in any and every way.

In the first example, I used the gem that is the Prismacolor Blender Pencil. I created various sized *Starfish* and then colored them, adding lots of different flourishes and features for you. These are just the beginning.

Tangle:
Starfish

Tip

The Prismacolor Blender Pencil is one of my favorite tools. You can color a tangle in various colors and then use the blender to soften the gradient merge of color. Try it out—you'll love it.

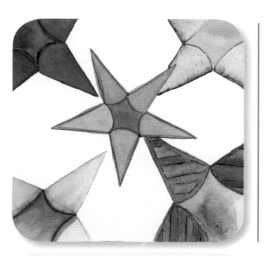

The second example is plainer and uses watercolor paints. Either opaque or transparent, these paints are so useful when coloring tangles. As with all things color, I encourage you to practice and explore options. Even if you don't like the end result, you'll have learned something.

Use these tiles to practice adding color to your tangles. Try markers and paint, pencil and pens. Use a combination of any and all.

Tangle:
Starfish

Starfish Borders

Borders can be incredibly simple or incredibly complex. When considering *Starfish* as a border, there didn't seem to be a logical way to make the *Starfish* shape while maintaining the true sense of a border. It occurred to me that the way forward was to use the shape of the star point, as I've done in both examples.

The first example has inward points, and I deliberately used bigger corner points to show that not all points have to be even.

In the second example, the points are all roughly the same size but have a variety of patterns on the inside, almost like a bunting. I love the way it works (and think about this one in color, too).

Can you think of alternative ways to use *Starfish* as a border tangle?

Use these tiles to practice using *Starfish* as a border and explore other ways you can create interest using this versatile tangle.

Starfish Letterforms

Hopefully you're enjoying the challenge of using *Starfish* in nonconventional ways because that largely continues this week as we explore *Starfish* as a tangle to create letterforms.

Continuing from last week, in the "B" example here, I used the star points as my shape builder to create the letter. As well as shading, I used the black created by the Micron pen to really give the work dimension and emphasize the shape of the "B."

Tangle:

Starfish (tangleation)

Alternatively, I used *Starfish* as a background tangle for the "V" example. *Starfish* is a great tangle for this purpose; it can be in the background of your focal letter. The added bonus is that *Starfish* doesn't have a set size, so you can use one large *Starfish* or several smaller ones. They all work.

Letterforms and *Starfish* are a great combination, whether the tangle is used as a shaper or a background. Explore the possibilities of *Starfish* and letters here.

Tangles:
Starfish, Shattuck

Starfish Shapes

When thinking about *Starfish* and shapes, it occurred to me that I'd be creating a shape with another shape. Tricky, or full of possibilities? Well, this is Zentangle, so it can only be a *good* thing, right?

In the first example, the *Starfish* was born out of the body of the butterfly. Butterflies so often have incredible patterns contained within their wings, the star being just a part of it. Although what I drew is a little different than a regular *Starfish*, it is a great way to create the butterfly's body.

Tangles:

Starfish, Fescu

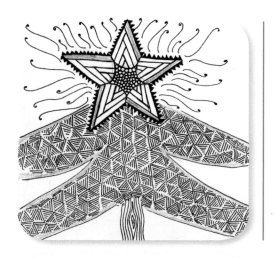

If you'll forgive me, this example might be a little obvious. A star? On a Christmas tree? Maybe a little . . . but if you tangle in the Christmas spirit, *Starfish* might just come in handy!

It's time to create shapes from *Starfish*. Use my examples as a launching pad to create a constellation of *Starfish*-inspired tangles!

Tangles:
Starfish, Swarm, Fescu

Starfish Zendalas

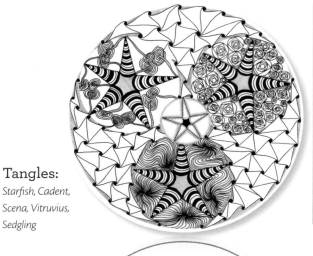

Tangles:
*Starfish, Cadent,
Scena, Vitruvius,
Sedgling*

If you haven't figured it out already, creating the Zendalas for this workbook was the most enjoyable part of the whole creative process. I'm not sure why, but all the tangles created here seem to work with Zendala really well. *Starfish* is no exception, and because of its singular nature, its suitability to base your Zendala around (as a centerpiece) is clear.

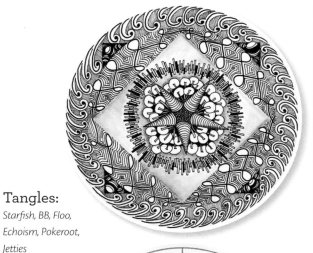

Tangles:
Starfish, BB, Floo, Echoism, Pokeroot, Jetties

I did that in this example as well (and used the Zendala from the *Zentangle® Untangled* gallery as inspiration), while using *Starfish* as the repeat pattern in the first example. What ways can you make *Starfish* the star of your Zendala?

Here's some space to really explore *Starfish* in the round. Think about how we've used *Starfish* in other examples and how they, too, can be used in a Zendala design.

I'm going to have to start this section with a small confession: as much as I'm a coffee addict, tiramisu has never been a dessert I enjoyed. However, I admire the layers of browns and beiges in the treat. When I was designing this tangle, the layers of cake sprang to mind, and the name *Tiramissoo* kind of stuck! So, meet *Tiramissoo*.

1 Draw thin double lines at even intervals across your tile (or a section of your tile).

2 Across each gap, draw a zigzag. Keep it as even as possible and not too thin—give the zigzag some space.

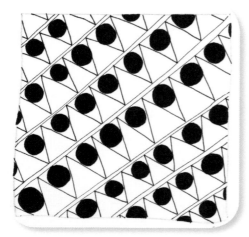

3 Inside the downward-pointing triangles of the zigzag, draw and color in circles.

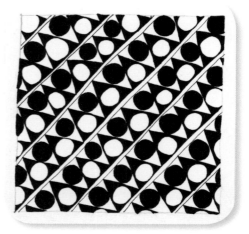

4 Draw a circle in the upward-facing zigzag, but color in the part outside of the circle.

TIRAMISSOO PRACTICE

This is a very flexible tangle that you can change up as desired. The key is consistency, however you choose to do it. Use these tiles to practice *Tiramissoo* and the many variations you can create.

Tiramissoo Shading

The beauty of *Tiramissoo*, especially in regard to shading, is that there are so many shading options in addition to or instead of using pen to create blocks of black. I've demonstrated two options here, but the possibilities are truly endless.

The first example is subtle; the shading is light between the thin "tramlines" that separate the zigzags. It's not obvious, but that light shading really distinguishes the zigzags of *Tiramissoo* from each other.

The second example is more obvious. Instead of blackening around the circles in the zigzag, I shaded. This changes the look of *Tiramissoo* entirely. It's up to you which style you prefer—or you can come up with something entirely new.

Tiramissoo has so many shading options. Here is your space to try a few out and see what you like best.

Tiramissoo Color

Tiramissoo is a tangle that invites color in all its glory. And I am happy to confess that, in these examples, I've been a little color happy—lots of it! Although I might not normally add color like this, it's a great way to show how color can influence a tangle and, in this case, how many colors can be included.

This example is actually a tangleation—a large triangle with *Tiramissoo* manipulated within it. It not only spills color, it also shows ways the tangle can work in another environment.

Tangles:

Tiramissoo, Rain

The second example is more traditional in its design, but I used various color combinations and black *Tipple* in the corners. I confess that I don't love the multiple use of color in *Tiramissoo,* but we learn as much from our mistakes as our successes in Zentangle, so I thought it important to include anyway. You might love it, and that's OK.

Tiramissoo can be multicolored, or you can use a limited palette—whatever suits your own art. Practice various color combinations here.

Tangles:
Tiramissoo, Tipple

Tiramissoo Borders

There's been a trend in recent years to go back to the simplicities in life, and the arts-and-crafts community hasn't been immune. One of my favorite old-school trends has been the reemergence of buntings. You see them in homes, at parties and all kinds of places now. To me, *Tiramissoo* is almost the bunting of tangles—both figuratively and literally! The example here demonstrates that beautifully. I've used *Tiramissoo* as an upper and lower border, but it looks like a bunting, too.

This example is a more traditional border. Instead of solid black, I used my Micron pen to create fine horizontal lines. It gives some solidity without being hard in appearance.

Try some *Tiramissoo* borders here, using both my ideas and any of your own. Remember that shading can play a huge part in the appearance of *Tiramissoo*.

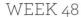

Tiramissoo Letterforms

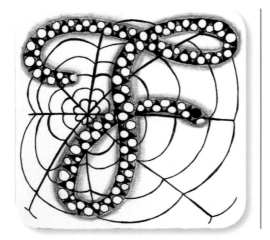

Tiramissoo, with its lines, can be incredibly useful when creating letterforms, even curly ones like this "F." It was important to follow the flow of the letterform on this, especially where the letter crosses over itself, but hopefully you agree that the final result looks fantastic. It looks complex, but actually it's very simple to create. A basic background like *Dyon* complements the letterform. If anything, it adds to the appearance of complexity that we know isn't really there.

Tangles:

Tiramissoo, Dyon

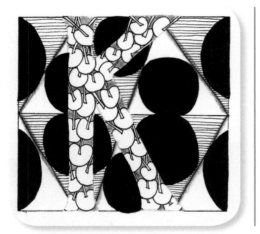

A larger interpretation of *Tiramissoo* became the background of the "K" letter. Using fine lines instead of solid blocking means that the "K" isn't overwhelmed. The shading of the *Pokeroot* also lifts the letter to the foreground. *Tiramissoo* doesn't have to be small; it can be enlarged and varied at will (remember what we did in the color section).

Letterforms are a lot of fun, and *Tiramissoo* is a flexible way to tangle a letter. Practice here and then branch out on your own. You'll love the results.

Tangles:

Tiramissoo, Pokeroot

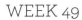

Tiramissoo Shapes

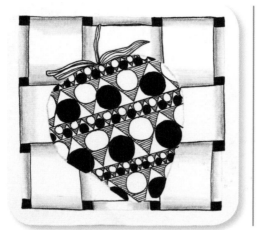

There's so much fun to be had with *Tiramissoo* and general shape building in Zentangle. *Tiramissoo* can be constructed en masse or in simple lines, meaning it works well in almost any tangle. The strawberry example looks almost good enough to eat! It feels almost touchable, especially with the basket look of *W2* in the background.

Tangles:

Tiramissoo, W2

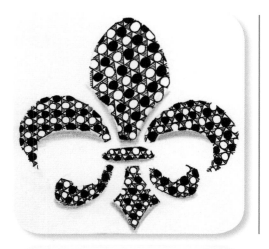

This example—the fleur-de-lis—is one of my favorite examples in this whole workbook. The smaller application of *Tiramissoo* as well as the way it's shaded makes it look rounded and off the page. I love it. You should definitely try this one yourself.

What shapes could you could apply *Tiramissoo* to?

There is so much potential for *Tiramissoo* in your tangle practice. Use these shapes to get a feel for it and then expand your horizons. Think big!

Tangle:

Tiramissoo

Tiramissoo Zendalas

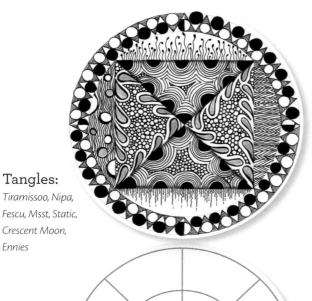

Tangles:
Tiramissoo, Nipa, Fescu, Msst, Static, Crescent Moon, Ennies

As we finish with *Tiramissoo* this week, look at how you can use this fun tangle with Zendala. The flexibility of *Tiramissoo* means it can be applied in so many different ways.

The first example here uses *Tiramissoo* as an outer circle. If you look carefully, you'll see that the outer circle is divided into quarters and the border has been alternated accordingly. This is a subtle change, but one that provides a point of interest for the viewer.

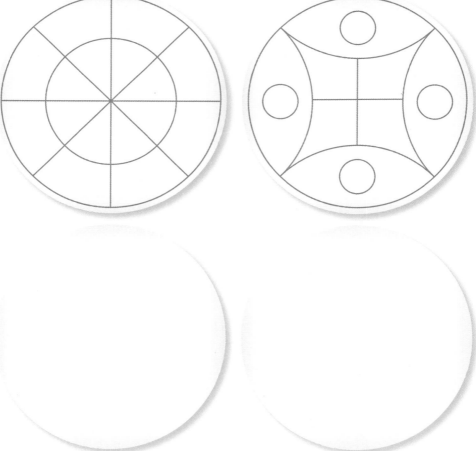

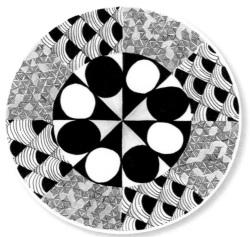

Tangles:

*Tiramissoo
(tangleation),
Swarm, Beelight*

Alternatively, the second example uses *Tiramissoo* in a different way. Rather than alternating in a line, it alternates in a circle—the inner circle here—with two other tangles in the outside sections. It maintains the concept of *Tiramissoo* yet it is a valid tangleation you can use in your own work.

Zendalas are so much fun, and there are so many choices available with *Tiramissoo*. Use these Zendala strings to practice your ideas for *Tiramissoo*.

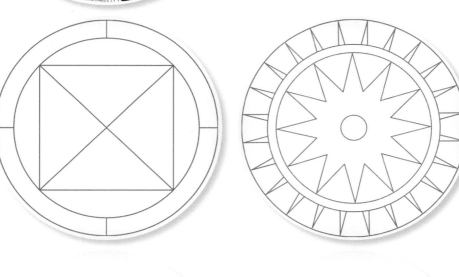

WEEK 51 PRACTICE TILES

Visit CreateMixedMedia.com/zentangle-untangled-workbook for extras.

WEEK 52 PRACTICE TILES

BONUS PRACTICE TILES

Visit CreateMixedMedia.com/zentangle-untangled-workbook for extras.

Index

About the Author

Kass Hall is an Australian mixed-media artist and writer. She has worked in the arts fields in Australia and Canada, and has published articles in magazines and newspapers in various countries. Her first book, *Zentangle® Untangled*, was published in 2012. Visit Kass at her website, www.kasshall.com.

About Zentangle®:

The name "Zentangle" is a registered trademark of Zentangle Inc.

The red square logo, the terms "Anything is possible one stroke at a time," "Zentomology" and "Certified Zentangle Teacher (CZT)" are registered trademarks of Zentangle Inc.

It is essential that before writing, blogging or creating Zentangle Inspired Art for publication or sale that you refer to the legal page of the Zentangle website.

Zentangle.com

Acknowledgments

Thank you to the mixed-media and art communities for their ongoing support of me and my work. My special thanks for the kind reception given to *Zentangle® Untangled*: those of you who have written to me, commented on my blog or reviewed my work. I am deeply appreciative.

Thanks to Amy Jones, Kristy Conlin and Tonia Jenny at F+W Media for their support and encouragement at every juncture.

My love and gratitude to my family and friends for their enthusiasm and support. Through good times and bad, I know you have my back.

And especially to Michael: my foundation and my reason for all I do. I love you millions. Thank you for being the man I dreamed of being loved by. And to Elvis and Sunny, our pug children. Mummy loves you more than anything.

Dedication

For my Kindred Spirits, near and far.

Metric Conversion Chart

To convert	to	multiply by
Inches	Centimeters	2.54
Centimeters	Inches	0.4
Feet	Centimeters	30.5
Centimeters	Feet	0.03
Yards	Meters	0.9
Meters	Yards	1.1

Other fine North Light Books are available from your favorite bookstore, art supply store or online supplier. Visit our website at fwmedia.com.

17 16 15 14 13 5 4 3 2 1

DISTRIBUTED IN CANADA BY FRASER DIRECT
100 Armstrong Avenue
Georgetown, ON, Canada L7G 5S4
Tel: (905) 877-4411

DISTRIBUTED IN THE U.K. AND EUROPE
BY F&W MEDIA INTERNATIONAL LTD.
Brunel House, Newton Abbot, Devon TQ1 4PU, England
Tel: (+44) 1626 323200, Fax: (+44) 1626 323319
Email: enquiries@fwmedia.com

DISTRIBUTED IN AUSTRALIA BY CAPRICORN LINK
P.O. Box 704, S. Windsor NSW, 2756 Australia
Tel: (02) 4560 1600, Fax: (02) 4577 5288
Email: books@capricornlink.com.au

ISBN-13: 978-1-4403-2946-3

Edited by Amy Jones
Designed by Amanda Kleiman
Production coordinated by Greg Nock
Photography by Christine Polomsky

Zentangle®
Zentangle.com
The Zentangle method is a way of creating beautiful images from structured patterns. It is fun and relaxing. Almost anyone can use it to create beautiful images. Founded by Rick Roberts and Maria Thomas, the Zentangle method helps increase focus and creativity, provides artistic satisfaction along with an increased sense of personal well-being and is enjoyed all over this world across a wide range of skills, interests and ages. For more information, please visit our website.

Love Tangling as Much as We Do?

It's your lucky day because there is so much more! Scan the QR code or visit CreateMixedMedia.com/zentangle-untangled-workbook for more tangling inspiration, printable practice tiles and Zendala starters designed by Kass.

Zentangle untangled

Inspiration and Prompts for Meditative Drawing

Kass Hall

These and other fine North Light products are available at your favorite arts-and-crafts retailer, bookstore or online supplier. Visit our website at CreateMixedMedia.com for more information.

Find the latest issues of *Cloth Paper Scissors* magazine on newsstands, or visit shop.clothpaperscissors.com.

 Follow us!
CreateMixedMedia

Follow us!
@CMixedMedia

Follow CreateMixedMedia for the latest news, free wallpapers, free demos and chances to win FREE BOOKS!

CreateMixedMedia.com

Connect with your favorite artists.
Get the latest in mixed-media inspiration.
Be the first to get special deals on the products you need to improve your mixed-media endeavors.

For inspiration delivered to your inbox, sign up for the free newsletter at CreateMixedMedia.com.